MASTERS OF PHOTOGRAPHY

WILLIAM HENRY JACKSON

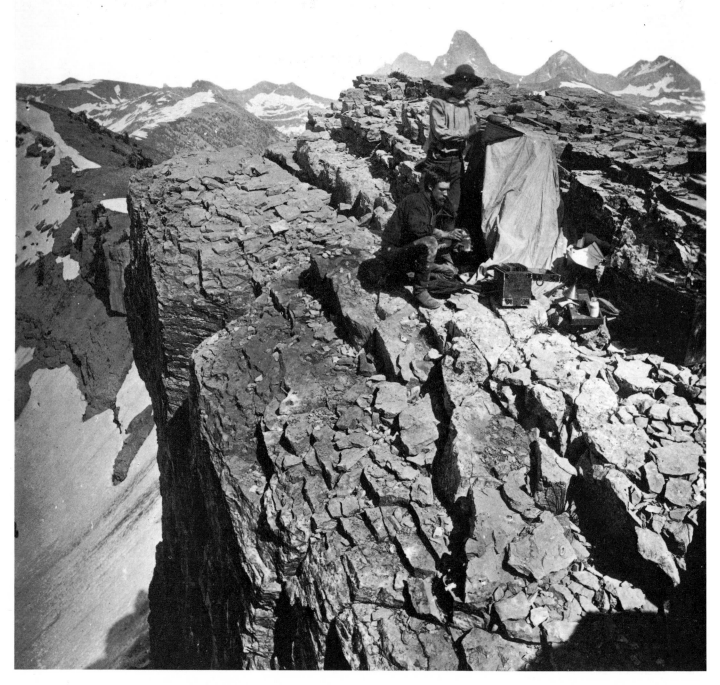

Jackson and his assistant, 1872. (National Archives, Washington, DC)

MASTERS OF PHOTOGRAPHY

WILLIAM HENRY JACKSON

Text by Peter Hales

Macdonald

A MACDONALD BOOK

© Macdonald & Co (Publishers) Ltd 1984

First published in Great Britain in 1984
by Macdonald & Co (Publishers) Ltd
London & Sydney

A member of BPCC plc

British Library Cataloguing in Publication Data
Hales, Peter
William Henry Jackson.—(Masters of
photography)
1. Jackson, William Henry
I. Title II. Series
770'.92'4 TR140.J27

ISBN 0-356-10510-5

Filmset by
Text Filmsetters Ltd

Printed and bound in England by
The Alden Press
Oxford

Macdonald & Co (Publishers) Ltd
Maxwell House
74 Worship Street
London EC2A 2EN

In 1900 a Denver publisher declared William Henry Jackson 'the world's greatest photographic artist'. His statement was only a slight exaggeration. Jackson was probably the most popular and important landscape photographer of the nineteenth century, and certainly the one whose work lies closest to the history, ideas and ideals of his century. Explorer, fact-gatherer, scientist, artist, propagandist and entrepreneur, Jackson was a model American of the period; his photographs moved a nation, both literally and figuratively.

Jackson's life was an action-filled microcosm of American history – he seems the perfect answer to Alexis de Tocqueville's famous question: 'Who is this new man, this American?' From the age of the individual to the age of the entrepreneur to the age of excess and, finally, to the modern age of empire and incorporation, Jackson's career twisted and turned along the same paths as did his country and civilization. And in each era, Jackson served as visual spokesman. He was the central photographer of his time.

William Henry Jackson was born in 1843 in Keeseville, New York, the son of a small-town blacksmith with the restless ambitions typical of Americans during those early years of nationalism and ebullient expansion. The young Jackson received the cursory education of his time – to read, write, do maths and memorize and deliver the speeches of great Americans. Along the way he began to imitate his mother's sketching. She bought him the bible of self-taught American artists of the time, J.G. Chapman's *American Drawing Book*, from which Jackson later recalled that he learned 'the mysteries of perspective, the rules of composition and design . . .' and the other laws of the amateur artist. He also reported that Chapman taught him other techniques which he later applied to his photography: 'how to economize, to eliminate, and to suggest, as well as to emphasize.' Jackson relates in his autobiography that he had great promise as a painter. He did not. Never more than a stiff, vernacular painter and draughtsman, he found his niche at the age of 12 painting scenes on window-screens for his provincial neighbours and constructing backdrops for

theatres and, eventually, photographers' studios. Jackson soon found himself a successful photographer's assistant, but he did not touch a camera or coat the glass plates of wet-collodion negatives until a decade later. Instead he corrected and improved negatives and prints by painting them, a skill which paid him $4 a week.

After a short stint in the army during the Civil War, Jackson resettled in Vermont where he appeared to have found his place in life with a fiancée and wedding plans, a well-paying job as retoucher for the Vermont Gallery of Art, friends and membership in the local literary society. But in 1866 a dispute with his fiancée shattered his complacency. Like some character in a period novel, he resolved to go West, in his words 'heading for the great open spaces to start life anew.'

During the next year Jackson visited Missouri, Nebraska, Wyoming, Salt Lake City and the other Mormon settlements of the Utah area and California via train, boat, wagon and on horseback and foot, earning his keep as a bullwhacker, or oxen-driver, when he worked. Then in August 1867, his restlessness abruptly played out, he settled in Omaha, Nebraska, again as a retoucher for a local photographer. Within six months he had bought out his employer, brought his brother West to run the business, learned the rudiments of commercial photography and was making a success of himself.

To round out his income, Jackson made photographs of Indians on the reservations near Omaha, studies of the half-constructed transcontinental railroad and views of spectacular natural scenery. These he sold to national distributors, where they subsequently appeared as small *cartes-de-visite* (mounted card photographs) or as stereographs, those immensely popular parlour-toys that provided millions with a three-dimensional view of the contemporary world.

To make his Indian and scenic views Jackson manufactured a travelling darkroom wagon which combined living quarters, storage for cameras and glass plates and a sensitizing and developing darkroom for his wet-plate negatives. This enabled him to stay close to his darkroom: wet-collodion plates had to remain damp from the moment of coating through exposure and development or they lost

their sensitivity; in the dry air of a Western summer, this could be a real problem, especially as the exposure for a scenic view might take ten minutes or more.

Jackson's great breakthrough came in the summer of 1869, somewhere in Wyoming, when he met one of the giants of the American West and its exploration, the geologist Ferdinand Vandiveer Hayden. Hayden was then in his third year as head of a government team sent to explore, survey, map and investigate the realities and possibilities of the region. Unlike some of his fellow government scientists, Hayden understood that a major part of his task was to open the American West to national and international consciousness, to provide a view of the West that would attract interest, support, investment and settlers. His chance encounter with Jackson apparently fixed the idea of using a photographer to do all this: the next summer he enlisted Jackson to join the visual arm of his exploration team and the photographer remained with him for the next eight years.

To a twentieth-century scientist, Hayden's Survey would seem a confusing mess, its mandate unclear, its team a curious hodgepodge of surveyors, geologists, philosophers and artists. Yet during the period from 1870, when Jackson joined, until it was disbanded in 1878, the Hayden Survey opened America's eyes to the geological fairyland of Yellowstone, the fabled Mount of the Holy Cross in the Rocky Mountains and the Indian cliff ruins of Mesa Verde. Hayden and his team, however, never discovered any of these; instead they explored and, more importantly, publicized each area. In so doing they provided an intellectual and mythic foundation for the near-hysterical wave of Westward emigration, settlement and acquisition that engulfed America after the Civil War. In this Jackson was crucial, even more important than the scientists who went along. Using a medium that linked science and art, fact and spirit, Jackson revealed the essential qualities of the West and reproduced the experience of contact with wilderness and God for millions of viewers.

The photographs Jackson made during the Survey years were extremely popular. Sold on the Hayden imprint, they reached parlours all over the United States and Europe in the form of stereo cards, full-sized photographs and photo-album books, such as Hayden's *Sun Pictures of Rocky Mountain Scenery* (1870). The photographs also influenced government opinion, guaranteeing continued support for exploration and even persuading Congress to make Yellowstone the first national park.

To obtain his views Jackson engaged in what to the modern photographer would seem heroic acts of courage and persistence. Working with a variety of cameras (some producing negatives as large as 20×24 inches), Jackson had to carry glass, chemicals and a darkroom wherever he went. Even when nothing went wrong he lived a rough and uncomfortable, if rarely dangerous, life with the survey team. His diaries abound in stories of days spent slogging through snow and slush in unmapped terrain to find a vantage point that would express both the scientific and artistic truths of the West. And on Jackson's successes hinged the success of the survey in general. Hayden's reports explained the new land to scientists; Jackson's photographs celebrated a form of American greatness in which settlers, businessmen, tourists and politicians could participate.

By 1878, however, the Survey's heroics had served their purpose and Jackson was out of a job. The contacts he had made during the Survey years, however, guaranteed him a living as a commercial photographer, capitalizing on the new role of the West in American life. His Denver, Colorado, studio produced portraits, city views, tourist photographs, souvenirs and a healthy income. Jackson, the adventurous discoverer and transmitter of the wonders of the West, became Jackson the prosperous commercial artist, spending his days at the stylish Colfax Avenue address of his studio, his evenings with his family in his fashionable home.

Over the next 15 years Jackson's photographs won him the highest honours in international competitions throughout the world, and his self-imposed title, 'America's greatest landscape photographer', seemed to match public opinion. In 1893 he mounted a major exhibit for the Baltimore and Ohio Railroad at the World's Columbian Exposition in Chicago, and then produced a set of

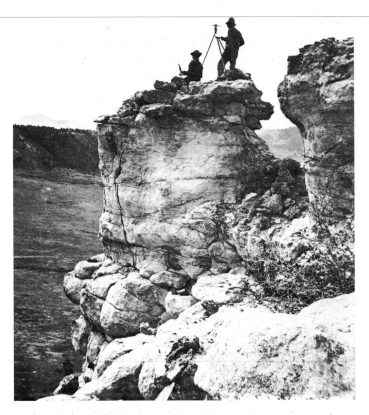

Topographical work, 1874
(National Archives, Washington, DC)

views for the World's Columbian Commission after the Exposition closed. In typical Jackson fashion he sold these two and perhaps three times, the pictures appearing in elaborate portfolios using the halftone reproduction process which was then revolutionizing the photographic community.

The crash and subsequent depression of the early 1890s threatened Jackson's livelihood; at the same time, halftone reproduction was impinging on the visual and marketing territory that Jackson had staked out after the Survey years. Therefore when Joseph Gladding Pangborn of the B & O Railroad invited Jackson to accompany the newly founded World's Transportation Commission on a five-year, all-expenses-paid, round-the-world trip at a munificent salary, Jackson jumped at the chance. As it turned out, he received no salary, the Commission ran out of funds after less than two years and the luxuries of travel quickly settled into tourist-class aggravation. Nonetheless the trip was

a major artistic experiment for Jackson and his last significant endeavour as a photographer. He funded the trip by selling his photographs to *Harper's Weekly* and for a period served once again as America's frontier explorer. Yet this frontier was not the West but the world – from Egypt to New Zealand and Siberia.

Jackson's return to the United States in 1896 was anything but triumphant. The Commission was bankrupt and in disgrace with its backers; his Denver company was still struggling and he was 53 years old and in serious financial straits. Lecture tours and other schemes failed or were abandoned. Then, in 1897, Jackson succeeded in selling his entire stock of negatives to the Photochrom Division of the Detroit Photographic Company (later the Detroit Publishing Company), a major international distributor of postcards, tourist views, fine art reproductions and educational sets. Jackson went in as a director in 1898 and spent the next decade contracting photographers and managing the production lines of the Photochrom and the Detroit Publishing Company. By 1902 he had effectively retired as a photographer, but the true end of his career had come with his assimilation into the Detroit Publishing Company. Jackson's life, from the bankruptcy of the Company in 1924 until his death in 1942 at 99, was in many ways as packed with stories as any other time in his life but by then William Henry Jackson was a citizen, not a photographer. Yet Jackson was the nineteenth century's most important landscape photographer, and his achievements reside alongside those of the greatest of that century.

Today we may appreciate Jackson's photographs for their technical craftsmanship, their vision of a lost wilderness, the difficulty of their making and even for their nostalgia. But to understand them fully we must know something of the time and culture in which they were made and in which their meaning and great beauty is imbedded. From the beginning Jackson's greatness as a photographer lay in his deep commitment to the central themes of the nineteenth-century American West: God, nature, land and man.

Stillness pervades the best of Jackson's early

survey pictures. Men stand alone or in groups, contemplating the vast, primeval world that engulfs them. We, too, are engulfed and are meant to contemplate our place in it as visitors and participants. Yet we are outsiders, not only because we have lost our innocence, but because Jackson drew from a whole body of American and European literature and art that stressed the vision of nature in general and the American West in particular as an Eden awaiting occupation.

Jackson's pictures document a particular moment when civilization and wilderness came together on the American continent. Beyond this intersection lay an unknown region which might be a Great American Desert or a Garden of the Gods, to borrow two phrases popular in nineteenth-century American writing about the West. Jackson's pictures of the frontier present it as a clear line between the known, the human, and vastness – the unknown. To pass beyond the frontier required heroism and a willingness to study nature for clues as to the future of the world and man's role in it. Scientists and artists associated with other surveys of the 1860s and 1870s were unabashed in portraying the American wilderness as a cataclysmic ruin or reclaimed Paradise. In both cases man and nature remained separated from each other: in one, man was too corrupt, in the other, nature too perfect. But Hayden and Jackson saw the West as a place where a fruitful meeting between man and nature might take place, in which both would be changed and civilized.

Such a system of belief explains Hayden's desire to have the West renewed and settled, and Jackson provided the impetus. What man would gain can best be seen in Jackson's photographs of the Mount of the Holy Cross, made during 1873. Jackson's story of the search, given the character of myth in its transformation from his diaries to his autobiography and to the contemporary accounts of journalists, is the story of a grail quest successfully completed. After days of difficult climbing along trackless wastes, Jackson and his companions were treated to a momentary vision of the fabled Mount on which Creation had inscribed 'the great shining cross'. Shortly thereafter a giant rainbow appeared – as potent an omen as one could

wish. But the light faded and Jackson and his companions shivered through the cold night without food, shelter or adequate clothing in order to make their photographs the next day. Published in stereo cards and full-size images, they were hailed as proof that God had blessed America.

That much of Jackson's story is fictitious, that he improved some, if not all, of the negatives by retouching one arm of the Cross, should only serve to emphasize how important Jackson's position was as a visual messenger and how much that position entailed the creation and substantiation of myths. Jackson's problem as an artist lay not simply in finding these remnants of a heroic nature or in recognizing their force and significance, but in communicating the potent themes to a worldwide audience. In this photography had a major advantage. It was, after all, believed to be the absolute truth-teller. In addition it was transportable and, more important, accessible to a wide public (its mass-reproduction technology had guaranteed a huge audience by the 1870s). Stereographs were to be found in nearly every middle-class house in America, part of the genteel parlour culture of conversation, diversion and armchair travel that characterized Victorian life. And the number of nineteenth-century houses with a Jackson photograph on the wall must have been staggering.

The peculiar mythology about the photograph which grew up in the nineteenth century was, however, the most important advantage. Viewers believed photographs told the truth in a scientific as well as an artistic way. They combined general truth (philosophy) with particular truth (science) in a way that the other arts could not. This persuasive power was particularly appropriate to landscape, which demanded both science and art. The photograph, because it was both science and art, was the perfect medium for communicating the religious and philosophical messages contained in the American West.

But Jackson did not simply invent a symbolic or formal language to tell these truths. Nor did he simply take the picture, depending on nature to tell her own truth, although he wanted his audience to think this was the case. Instead, he learned and adapted a set of widely understood visual conven-

tions found in nineteenth-century art. These he received from a variety of sources: Chapman's *American Drawing Book*, the photographic backdrops he had learned to paint at the age of 12, the popular lithographs of his time, the illustrations in popular magazines and books. Once on the Hayden Survey he had the tutelage of one of America's supreme landscape painters, Thomas Moran, who taught Jackson how to compose proper landscape images on the ground glass of his camera. Jackson reported in his diary of 1872 that Moran 'gave unstintingly of his artistic knowledge especially with regard to the problems of composition. . . .'

These were the sources for Jackson's early understanding of the sublime, the picturesque and the beautiful, three crucial terms for Romantic landscape. Each represented a set of ideas about nature, as well as instructions in how to present her as art. The sublime and the beautiful were terms drawn from the work of the eighteenth-century English philosopher Edmund Burke and popularized in Jackson's day by a number of writers; the picturesque was a more amorphous and general term. Sublimity emphasized nature's awesomeness, even hostility: the power of Creation and the puny insignificance of man. Conversely, the beautiful stressed the harmony, generosity and orderliness of nature and presented man as an invited guest, even a necessary gardener. The picturesque emphasized a point in between whereby man remained separated from nature, yet appreciated and learned from her.

We can see how Jackson compressed all of these concepts into one superb whole in 'Laramie River and Valley looking Northwest, Albany County, Wyoming, 1870'. The foreground is harsh, sterile, even threatening. But the picture draws us deep into space — past the man who rests, contemplating the scene below. To his right two men do likewise; we are drawn into a community by the act of sharing the vision below. There, by a still, reflecting river (made mirror-like by the long exposure time), is a land of harmony where horses drink and bountiful grasses promise superb farmland. Beyond this haven stretches the sublime space of the West.

Symbols of the power, grandeur and infinity of nature appear in nearly all of Jackson's Survey

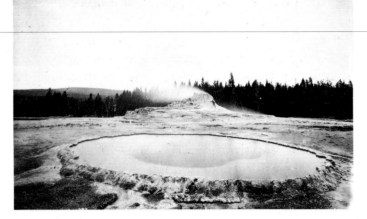

Crater of the Castle Geyser, Yellowstone, 1871
(National Archives, Washington, DC)

photographs. In some the simple vastness of space serves as symbol; in 'Camp in Cache Valley, Utah, 1871', the mountains appear to look down protectively. In others the vast blankness of white sky impresses the viewer with a sense of infinity and awe (here Jackson was exploiting a technical limitation of the wet-collodion negative: its extreme sensitivity to blue light, which caused skies to turn white, or solarize into a mottled grey). Time and again Jackson composed his photographs to give tremendous force to broad, blank areas.

In Jackson's photographs nature is infinite and infinitely powerful but rarely hostile. Instead Jackson transformed threat to spectacle, and even lesson. This is particularly true of his famous views of the Yellowstone region. In 'Mammoth Hot Springs, Yellowstone, 1872' we see the geological effects of the springs (science) revealed as a vast trash-heap for geological forces (philosophy); Jackson has transformed this into a swirling composite of curves and diagonals which surround the central image of the falls (art). His view of the Pulpit Terraces at Mammoth Hot Springs is a reminder that nature is art and God the divine artist. The still pool, the dead trees, the snowy rock face are all symbols of the raw force of nature tamed and transformed into beauty.

Here man is a student; in Jackson's later pictures he becomes a tourist. But this transformation had not occurred in 1871 when Jackson made his view of the crater of Castle Geyser. Then his in-

terest lay in chronicling the heroics of the Survey scientists, who risked themselves to gain insight into the workings of this amazing geological structure. Yet the picture conveys less a sense of danger than adventure; the tiny figure climbing the far geyser seems not only undaunted but unthreatened. Nature, we think, will surely stay her hand. The pool and the trees contribute to this feeling, as does the geyser itself, which seems more a creator of visual effect than a hostile force.

Man's place in nature was a crucial issue for Jackson and his age and was debated on political, scientific, philosophical, religious and artistic grounds throughout the nineteenth century. As an artist and an explorer-scientist, Jackson was required to communicate his conclusions, and he did, even though they often contained conflicting components, as he attempted to resolve the conflicting beliefs and myths that surrounded and influenced his ideas. Certainly man was a minor and temporary occupant of this vast and potent realm. But Jackson's role was as a bearer of good news: that the West could be converted from wilderness to pastoral garden. Thus his studies of Survey settlements, such as the 'Camp in Cache Valley', are nearly all meant to presage permanent settlement and cultivation.

If Jackson's pictures of American explorers, settlers and settlements celebrated a stage in the transformation of wilderness into pastoral setting, his images of Indians reflected the deeply confused attitudes of his time: Indians were considered unattractive examples of human decay – and dangerous impediments to settlement. This attitude characterized many of Jackson's views from the period before the Survey, and reflected the ideas of his fellow settlers in Omaha and throughout the frontier. Unflattering views of Indians also suited the needs of Jackson's clients, both real and hoped-for – businessmen, land speculators and the railroads.

Later images from the post-Survey years presented a more heroic Indian, the noble savage whose contact with nature provided wisdom and serenity. These views emphasized the picturesque, even eccentric, details of Indian costume, as in 'Buckskin Charlie, Ute'. They reflect a prevailing mythology about the Indian, one that appeared in literature from James Fenimore Cooper to the dime-novels of the 1880s and 1890s.

During the Survey years the Indian pictures Jackson claimed as his own were, in the main, more analytic and less heavy-handed than either the early or later views. But because Jackson noted in his catalogue for the government in 1877 that he had included many pictures made by other photographers, determining which pictures are actually his becomes an extremely difficult problem. Still, the 1874 studies of cliff dwellings and other remnants of the Mesa Verde culture are surely his own. Here Jackson presented the Indian as a consummate adapter to the harsh necessities of Western life. His view of the 'Cliff Ruins in Mancos Canyon' exemplifies this work. Jackson reported in his diaries that 'perched away in a crevice like a swallow or bat's nest, it was a marvel and a puzzle'. What astonished him and his fellow explorers was its size, 'about 12 or 14 feet [3½ or 4½ metres], divided into two stories'. The Indians had effectively miniaturized their lives to fit into the crevices of the huge rock faces along the Mancos River, and Jackson posed his fellow travellers to make clear how small the dwellings were. In his best view he set his camera vertically so that the eye nearly misses the ruins in the tall cliff; the rock seems ready to collapse at the slightest urging and the cliff is reduced by the extraordinary sweep of space behind it and the vertiginous height above the canyon. When we do discover the dwelling and its nonchalantly posed discoverer, the scale humbles us and makes the man seem foolishly unaware of his danger and ultimate unimportance. The long-extinct cliff dwellers seem far more intelligent in their vision of nature than the explorer: they recognize the power and danger surrounding them and have adapted by becoming a part of nature.

Jackson's departure from the Survey in 1878 signalled an important change in the American West, and one in which Jackson played a crucial role. In the decade following the completion of the transcontinental railroad the settlement of the West had become a reality: cities grew throughout the region between the two coasts and their stone buildings replaced the tents of the early days. It was in one of these new cities that Jackson chose to

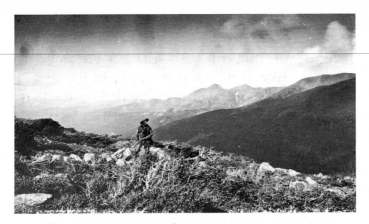

North from Berthoud Pass, Colorado, 1874. Harry Yount, professional hunter and later first ranger of Yellowstone National Park. (National Archives, Washington, DC)

adapt his photographic vision to the new realities and myths of the new West. Denver was a perfect place: a major commercial and economic centre for the mining regions to the west and the plains to the east, and a crucial transportation hub for the entire West. Therefore it offered a variety of markets for photography, including portraits, business advertisements, news and local history, and souvenirs for the hordes of tourists who flocked to the Queen City of the Plains on their way to the fabled Rocky Mountains or the visual delights of Yellowstone, Yosemite, or the northern California coast and picturesque San Francisco. Jackson became a commercial photographer and as a result the overall quality of his work dissipated. Yet he never lost his instincts for the consciousness of his culture and time and as a result many of the tourist views of areas in the Rockies and the railroads are among his most compelling photographs.

Jackson was now working extensively with the largest available cameras: 20 × 24-inch negatives produced spectacular prints as big as most easel paintings, forcing the viewer into the scene. His 'Canyon of the Rio Las Animas' is an excellent example of this, its grand sweep turning trees, rocks, water and railroad tracks into scenery. The view is emphatically picturesque: everything is in place and well composed; we are welcomed, not threatened by the scene. This was a quality increasingly evident in Jackson's Denver work, and completely absent from the Survey photographs.

By the 1880s Jackson's great talents had made it possible for him to make rather than take photographs – to arrange each image perfectly. Combined with his prosperity and his new role as client-centred photographer, this resulted in pictures which were often stilted. His advertisement reflected an emphasis on size and variety over exploration.

As the Jackson Photograph and Publishing Company became a factory of picturesque views, Jackson began to disappear into the general high quality of his company's output.

If today we have difficulty separating Jackson's work from that of his assistants during this period, it is a testament to Jackson's rigorous editorial skills and his ability to teach his apprentices the requirements of picturesque landscape photography; it is also, however, an indication that he had become a prisoner of his own visual and intellectual habits. He was no longer an adventurer; he was a prosperous, if predictable, craftsman.

His own best work, however, continued to reappear in fits and starts, usually when focusing on the railroad's heroic path through a wild but restrained nature. The more hostile and sublime the natural scenery, the more heroic the act of conquering became; the viewer's awe is now directed at the feat of engineering rather than at nature. But Jackson often was able to balance the two, and when he did, as with 'Sentinel Rock and Tunnel on the Moffett Road', he produced images which approximated his views of the cliff-dweller ruins. In this picture, for example, nature seems unaffected by man, who has adapted his technology to fit her demands.

Yet even Jackson's celebrated railroad views showed signs of facility, the adventure of discovery now muted to the pleasures of familiar treatment. Reputation, connection, location in a boom-town in a boom-era all guaranteed Jackson an increasingly central place in American photography throughout the 1880s and early 1890s. The panic and crash of the 1890s, however, abruptly punctured Jackson's complacency. His decision to accompany J. G. Pangborn on his grandiose goodwill world tour must be seen as an attempt to redeem himself and his vision and America's sense of exploration and adventure.

The year before Jackson left on his trip he was a

part of an elegy to the frontier and a celebration of its passing. At the World's Columbian Exposition, while Jackson stood at the B & O exhibit of his pictures, Frederick Jackson Turner was pronouncing the end of the frontier and Jacob Riis was proclaiming the necessity of facing up to the decay and chaos of a mature culture rather than escaping into the myth of a free past. Jackson, photographing the Exposition after its closing, presented it as a civilized replacement for the old America.

In his own life, and the life of the nation, the end of the frontier seemed grimmer and more compelling. Jackson turned to the world because there was no other safety valve. From London he wrote to his wife: 'One reason why I was so anxious to go on this expedition at any cost whatever was to establish a new starting point in our career—to be able to draw a line separating our old way of getting along. . . .'

Yet in escaping his business failures and debts incurred in land speculation, the increased competition from the new halftone processes, the West and its lack of possibility, he carried the ideology of the frontier, of manifest destiny and the covenant between American nature and American man.

Jackson's photographs of the world re-explored the issues of time, history, civilization and nature which had made him the central artist of the American West. But Jackson was now more like Mark Twain's innocent abroad – his America was the new civilization, ignorant of history. The photographs show that Jackson could still apply his Survey techniques to global mysteries and derive lessons that the readers of *Harper's Weekly* could learn and apply. His early study, 'Wagon Road Approach to Constantine (Algiers) from the North' is a variation on his views of the cliff-dwellers, but it celebrates the abilities of an older civilization to mould nature rather than adapt to her. His views of geysers in New Zealand drew upon his work at Yellowstone 20 years earlier, but reinterpreted the natural phenomena using the languages of Impressionism and pictorialist photography. These conventions could be applied equally well to the freight yards of a New Zealand city; what mattered now was not the subject but its transformation. Jackson's photographs thus became more in tune with the current fashions of high art photography.

But this obeisance to the fashions of the time is only one aspect of Jackson's photography for the World's Transportation Commission. The other lies in his striking studies of men and nature. As in the Survey years, Jackson's attention turned to the infinite, especially to infinite space. His study of the Choonbatty Loop is both humorous and shocking. The members of the Commission and their train seem foolishly out of place in a landscape of lush growth, grotesque death and blank, endless space.

We cannot make as complete a description of Jackson's Commission work as we can of earlier eras because the pictures are still being discovered after having disappeared from public view for nearly a century. We can conclude, however, that Jackson was struggling to reinsert himself in the central issues of his time; that he sought and often found the visual means necessary for such an exploration, and that this new investigation was more deeply personal than ever before.

Jackson's decision in 1897 to immerse himself and his work in the anonymity of corporate mass-production image-making might seem tragic to us, but in fact it was a graceful bow to the inevitable. Jackson and his photographs simply could not have survived in the twentieth century. They depended upon a widely shared faith in America, in progress, in the individual, in common heroes, in the possibility of a communal rediscovery of nature. The twentieth-century artist has taken the role of exile from a civilization threatening to choke itself on boredom and ignorance but for the jabs of individual outcasts such as himself. Because we have come to accept this notion of the artist, it is the one we expect. We find it harder to recognize the visionary in Jackson precisely because he was so complete a believer in the myths of his time and place.

Luckily, Jackson's photographs have withstood 50 years of harsh criticism and remain immensely potent and moving works. Through them we can reclaim the innocence, faith and energy of nineteenth-century America as it stood at the edge of the frontier and contemplated the wilderness. With a little practice perhaps we, too, can see the special mission of man to transform self, society and environment into a perfect world – to recreate Eden.

FRAMING AND MOUNTING

There are a number of ways to display photographs, depending on your personal taste, the picture itself, your initiative and the amount you wish to spend. The simplest method is to use ready-to-assemble framing kits, which will only take about 10 minutes of your time; but if you want a truly professional look, you might wish to mount or mat your photographs and then have them framed – or do it yourself.

Mounting

Like any kind of print or drawing, a photograph must be secured to a stiff surface before it is framed to keep the picture flat and to keep it from slipping about inside the frame. There are a wide variety of mounting boards available, in many colours and thicknesses, or weights, so it is best to go to an art shop, tell the assistant what you need and look through their stock. Remember, if the photograph is large you will not want the board to be so heavy that when the picture is framed it falls off the wall!

There are three mounting techniques: dry, adhesive and wet. Dry mounting should be left to a professional (most photographic processing firms offer such services) because it requires a special press, but the other two methods can be done easily at home.

Adhesive mounting

You will need a sheet of glass slightly larger than your mount to use as a weight; a soft cloth or rubber roller (4-6 in/10-5 cm) and a wide brush. When choosing the adhesive avoid rubber solutions because they lose their adhesiveness when they dry; spray adhesives (which can be bought in any art shop) are quick and less messy – test the spray on a piece of paper before you begin to gauge its density. Sheets of adhesive are also available but require a perfect eye and steady hand. If you feel confident, they are an easy way to mount a picture. Tape should not be used except as a temporary measure.

First calculate where the picture is to lie on the board and lightly tick the four corners with a pencil or prick them with a pin. Read the manufacturer's instructions on the adhesive and then apply it to the back of your print. Carefully position the print on the front of the mounting board and smooth out any wrinkles with the roller or cloth, working from the centre outwards.

Because the mount will tend to warp as the adhesive dries, the picture must be counter-mounted. Cut a piece of heavy brown craft paper the same size as the mount. Lightly dampen one side of the paper with clean water, apply adhesive to the other side and then secure it to the back of the mounting board. As the paper dries, it will counter-act the drying action of the photograph. Place the picture and mount under the sheet of glass until completely dry.

Wet mounting

Wet mounting is used for creased, torn or very old photographs. Immerse the photograph in clean water and place it face down on a sheet of glass. Using a brush or roller, carefully smooth the surface and apply a thin coat of adhesive to the back of the picture and to the mounting board. Put the picture on the board and gently press out any bubbles. Countermount the board (see above). Check the photograph for any wrinkles or bubbles and smooth out. Let the adhesive dry until it is just moist and place the mounted photograph under the sheet of glass and let dry completely.

Block mounting

This is especially effective for large photographs and means that no frame is needed. Self-adhesive commercial blocks are available in standard sizes but tend to be expensive. To make your own you will need a piece of mounting board about ⅜ in (9 mm) smaller than the print on all sides; cellulose adhesive, a brush, lots of newspaper, a soft cloth or

rubber roller, a large piece of card, a sharp craft knife, a cutting mat and piece of fine glasspaper.

Mix enough cellulose adhesive to cover the print and the board (the board will absorb the first few coats, so make a lot). Soak the photograph in clean water for about 20 minutes. Place several layers of newspaper on your work surface and place the mounting board on top. Apply the adhesive to the back of the board in two applications. Remove your print from the water, let any water drip off and place it picture-side down on the work surface and cover the back with adhesive. Then position it carefully on the board, picture-side up. Using the soft cloth or roller, carefully push out any bubbles or wrinkles from the centre outwards. When dry, put the mounted print picture-side down on a piece of clean card (do not use newspaper or paper, which may damage the print). Put some heavy books evenly on top as a weight and let dry thoroughly (this can take up to two days.) When dry, put the board picture-side down on a cutting mat and, using a sharp knife, trim the excess edges of the print to the edges of the mounting board. Smooth the edges of the board (not the print) with glasspaper. Paint the edges of the board or leave neutral.

Matting

A mat can change any photograph into something quite stunning. It will require a certain amount of experimenting to determine what size border around your picture looks best: some photographs are heightened by having a very wide border, others need almost none at all. In all cases, however, it looks best to have the bottom border slightly wider than the other three. As well, there is a vast range of colours of board to choose from, so think these things through before you buy your supplies. Remember that the mat should never overwhelm the picture, but should simply enhance it.

You will need a very sharp craft knife, metal straightedge and steel tape, large or set square. cutting mat and sharp pencil.

First measure the board to make sure that it is square (the right angles at the corners should be exactly 90 degrees) and trim if necessary. The aperture, or opening, for your picture should overlap the print by about $1/8$ in (3 mm) all round. You can mark this on the board either in pencil or with pin-pricks at the corners. If marking with pencil, do so on the back of the board and cut from the back as well so that the marks will not show.

Before you begin cutting, it is a good idea to practise using the knife and straightedge, which can be tricky for the uninitiated, especially on the corners. Position the blade of the knife at either a 90-degree (for a vertical edge) or 45-degree (for a bevelled edge) angle to the straightedge. Draw the blade firmly and slowly from corner to corner. Avoid stopping, as this will produce a ragged edge, and be careful not to gather speed and overshoot the corners. When all four sides have been cut, lift the centre out. Use glasspaper to neaten the edges.

The mat can now be secured to the mount with adhesive. To make a permanent bond, coat both the mount and the mat with adhesive, let dry and then press together. For a less permanent bond, apply adhesive to only one surface. Your picture is now ready for framing.

Frameless Frames

Photographs can be displayed most effectively without frames to detract from them. There are many types of frameless frames available in standard sizes, from 8 × 10 in (18 × 24 cm) to 24 × 32 in (50 × 70 cm). Most are easily obtained from art shops – your only decision is the size you need and the amount you wish to spend. If you prefer, you can easily make your own. You will need mounting board, a mat, glass or acrylic, and clips or brackets. There are, again, a wide variety of clips and brackets available. The least obtrusive are known as Swiss clips. Whichever you choose, make sure they will fit the width of the mount, print, mat and glass.

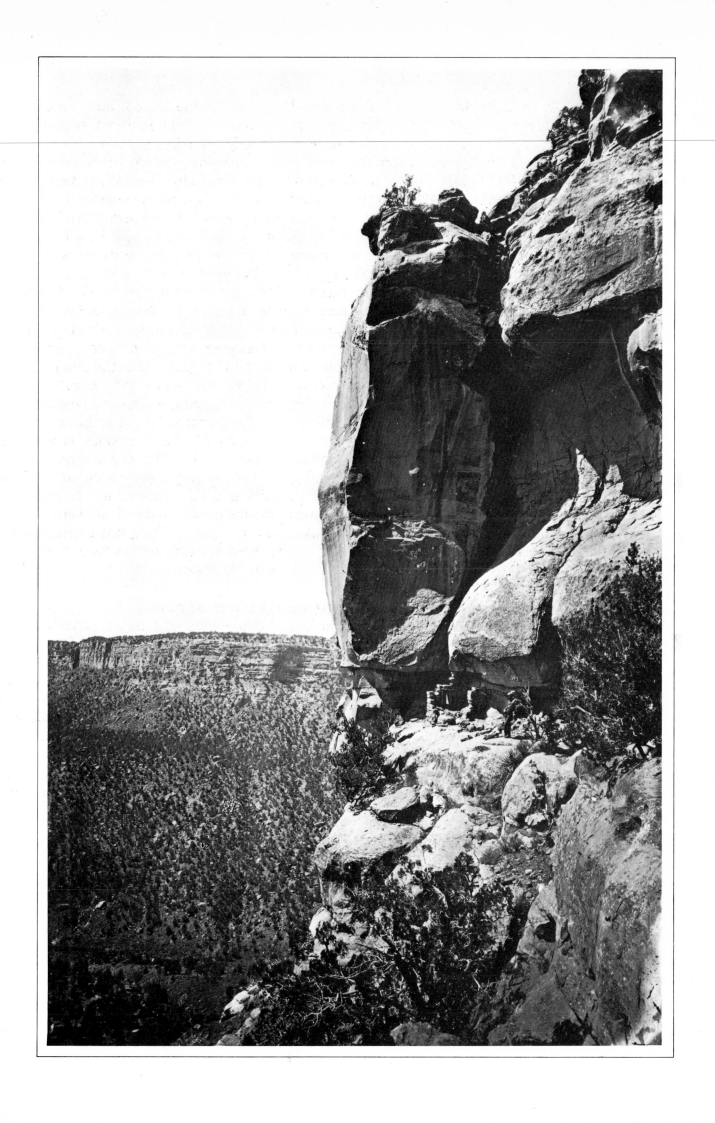

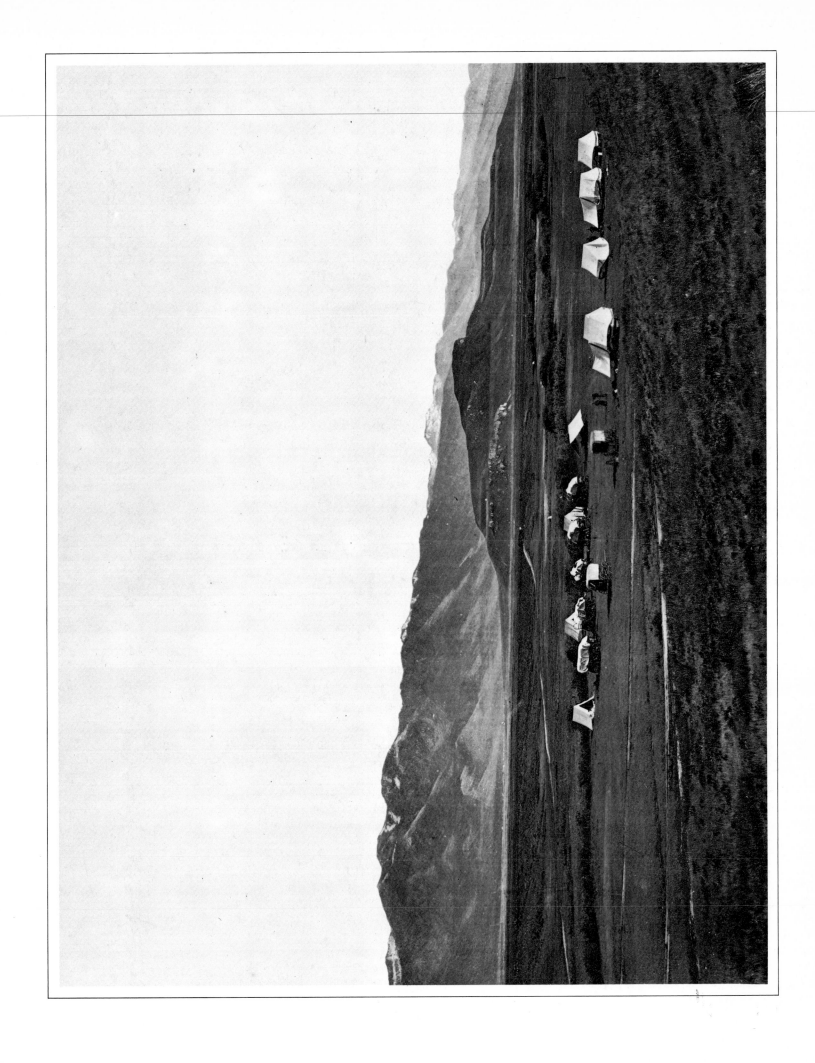

Camp in Cache Valley, Utah, 1871 (National Archives, Washington, DC)

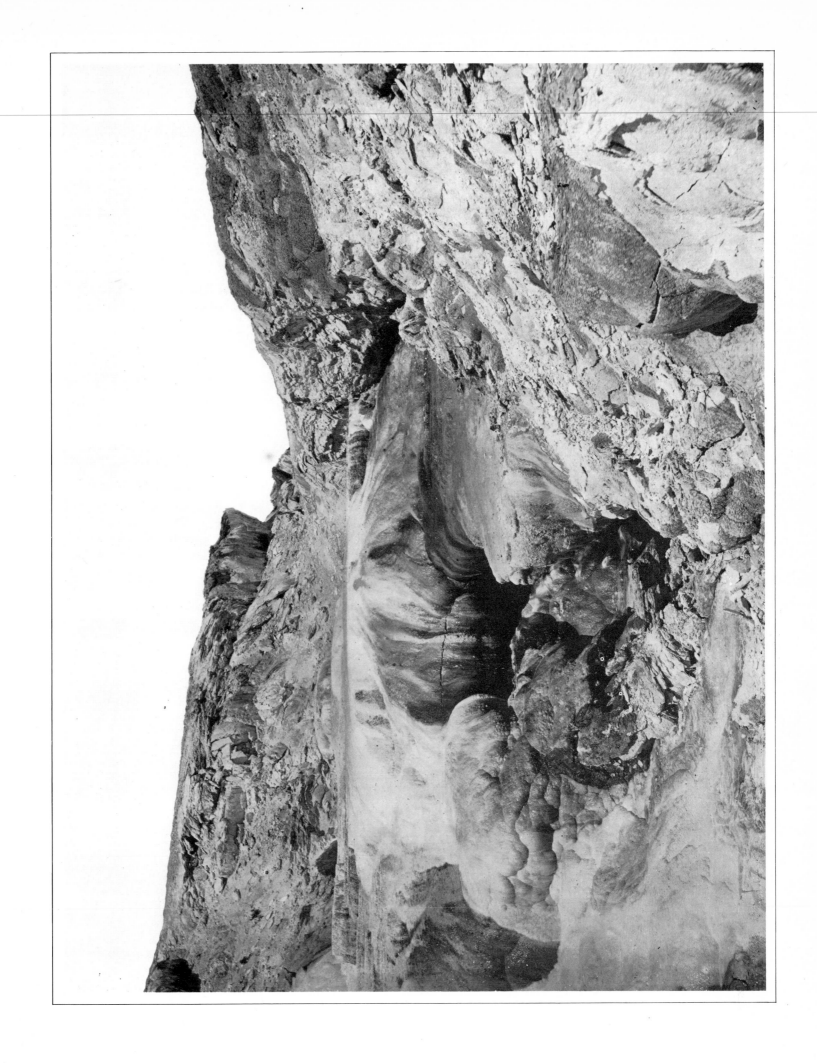

Mammoth Hot Springs, Yellowstone, 1872 (National Archives, Washington, DC)

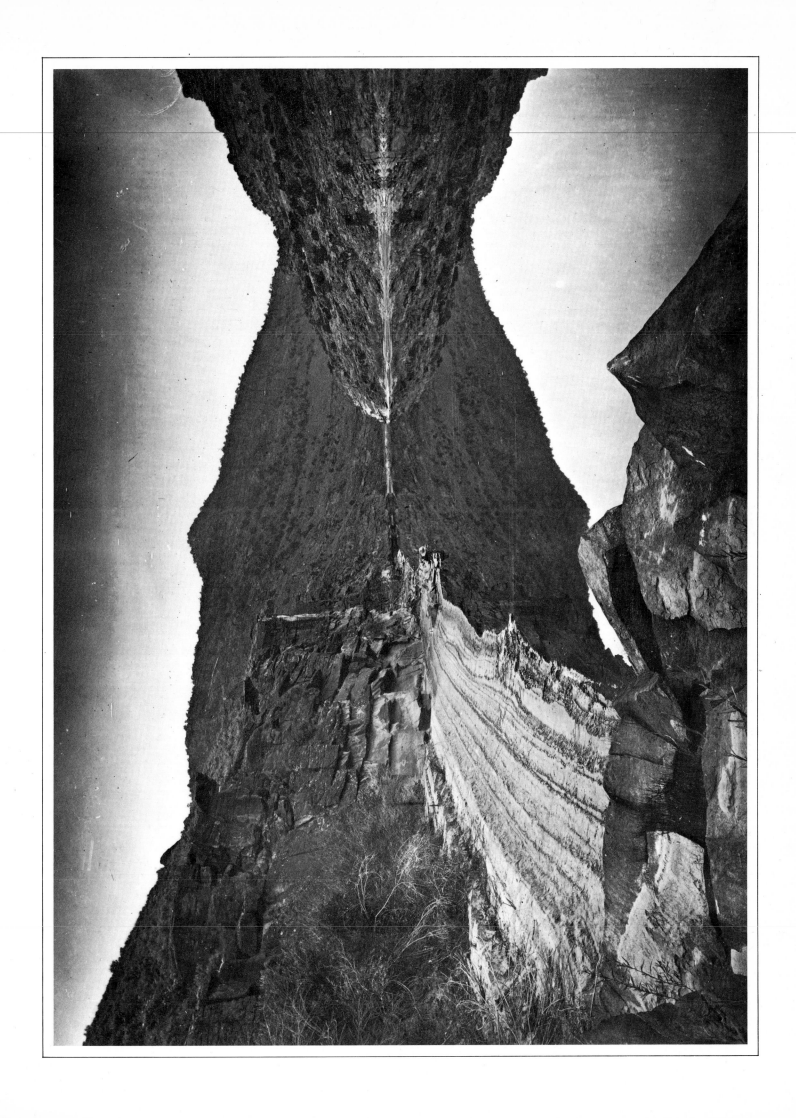

Green River at Brown's Hole, Daggett County, Utah, 1870 (National Archives, Washington, DC)

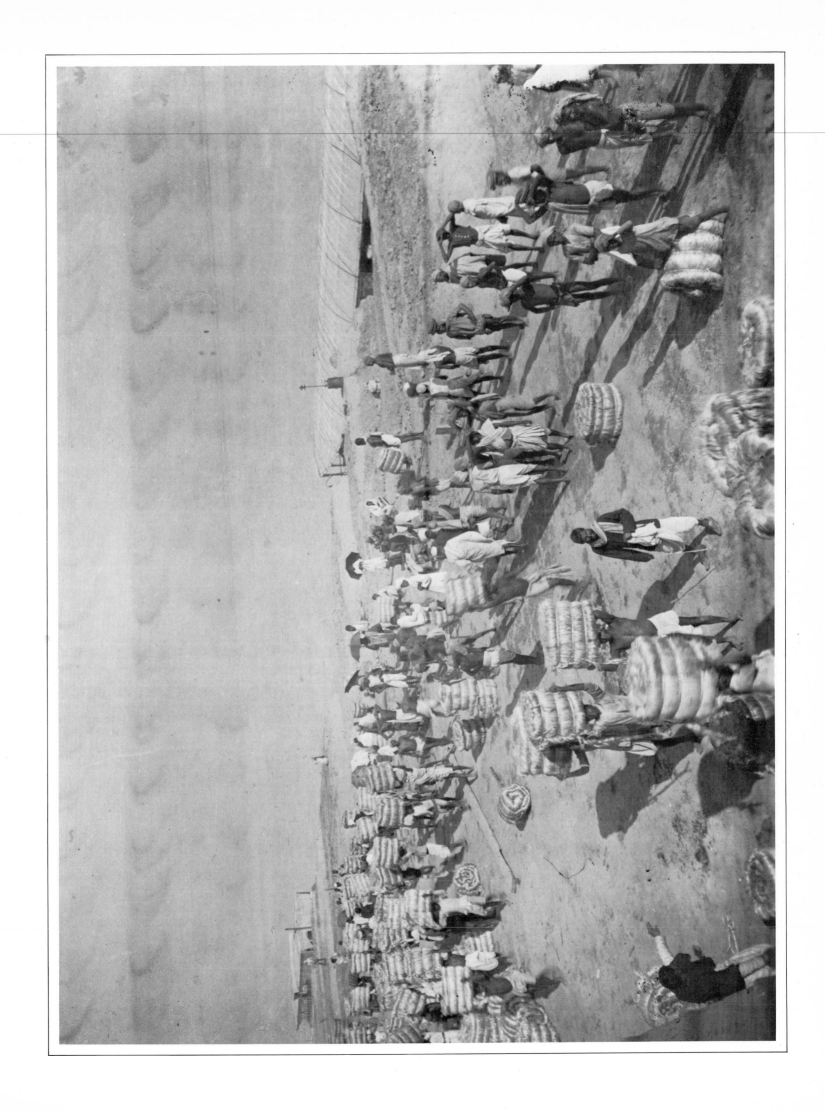

Coolies loading bales of jute, India, 1895 (Library of Congress, Washington, DC)

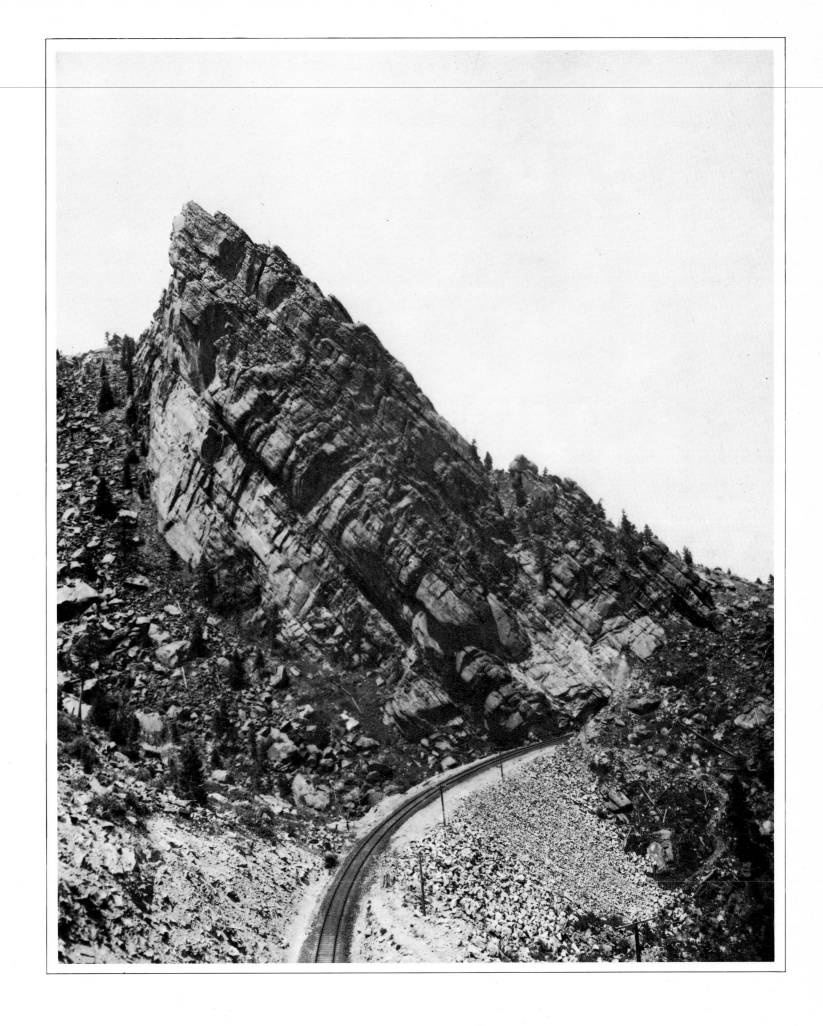

Sentinel Rock and Tunnel No. 6 on the Moffet Road, Colorado (Colorado Historical Society)

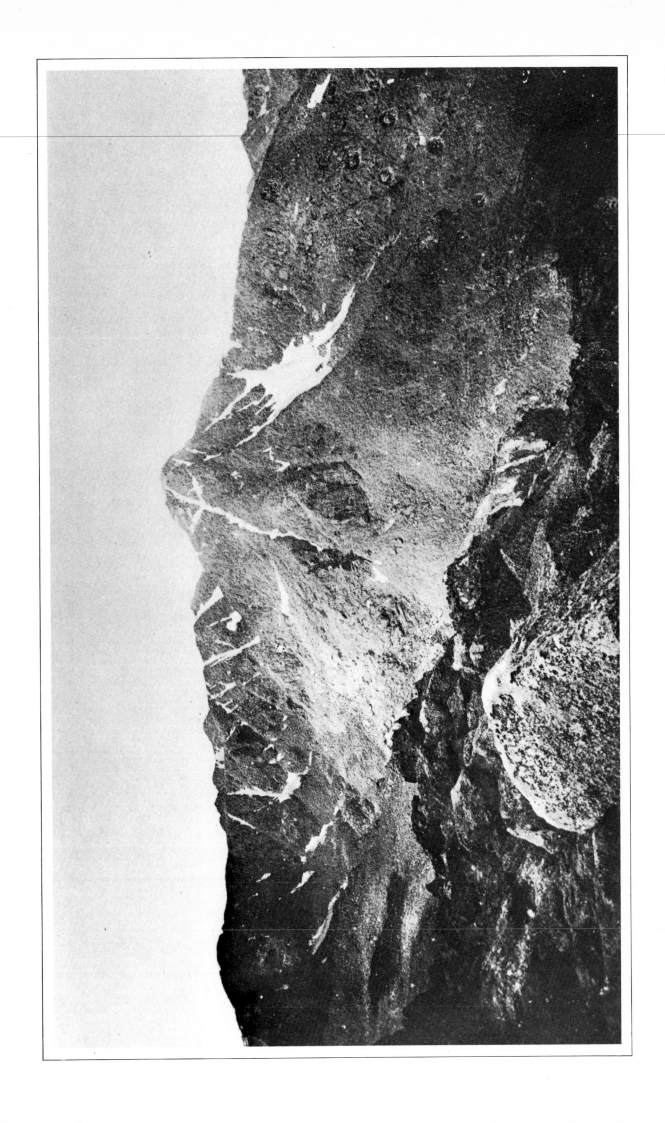

Mountain of the Holy Cross, Eagle County, Colorado, 1873 (National Archives, Washington, DC)

Street view in Corinne, Box Elder County, Utah, 1869 (National Archives, Washington, DC)

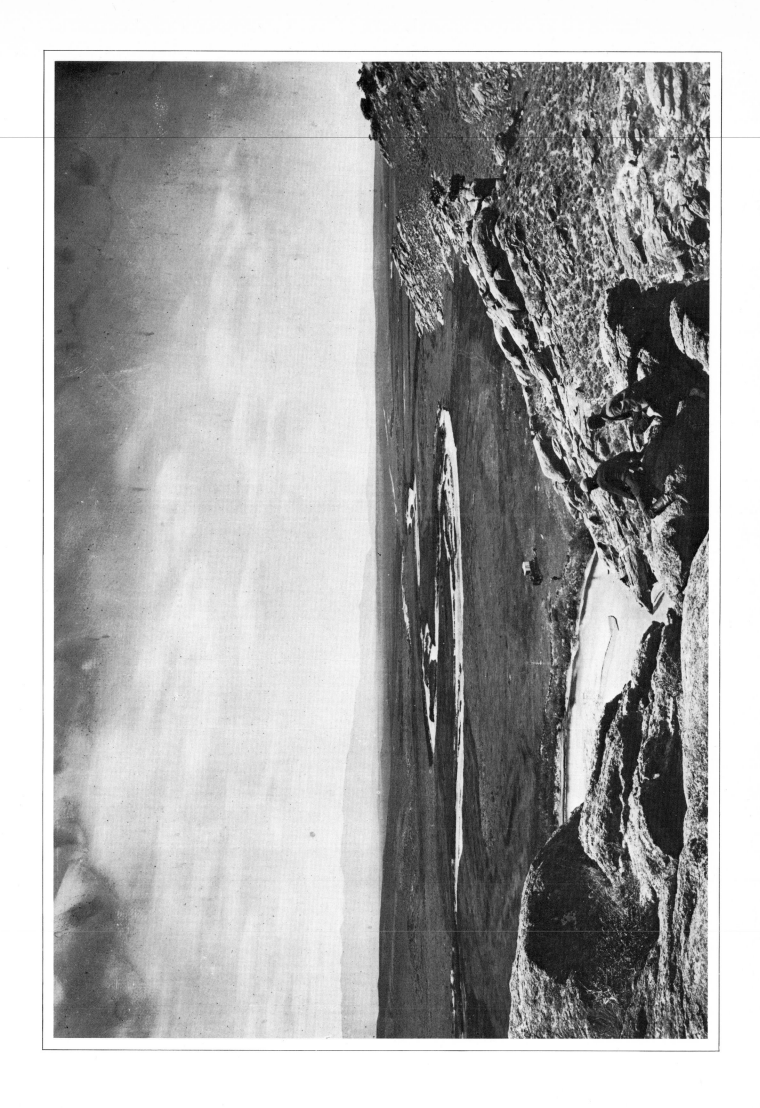

Devil's Gate, Freemont County, Wyoming, 1870 (National Archives, Washington, DC)

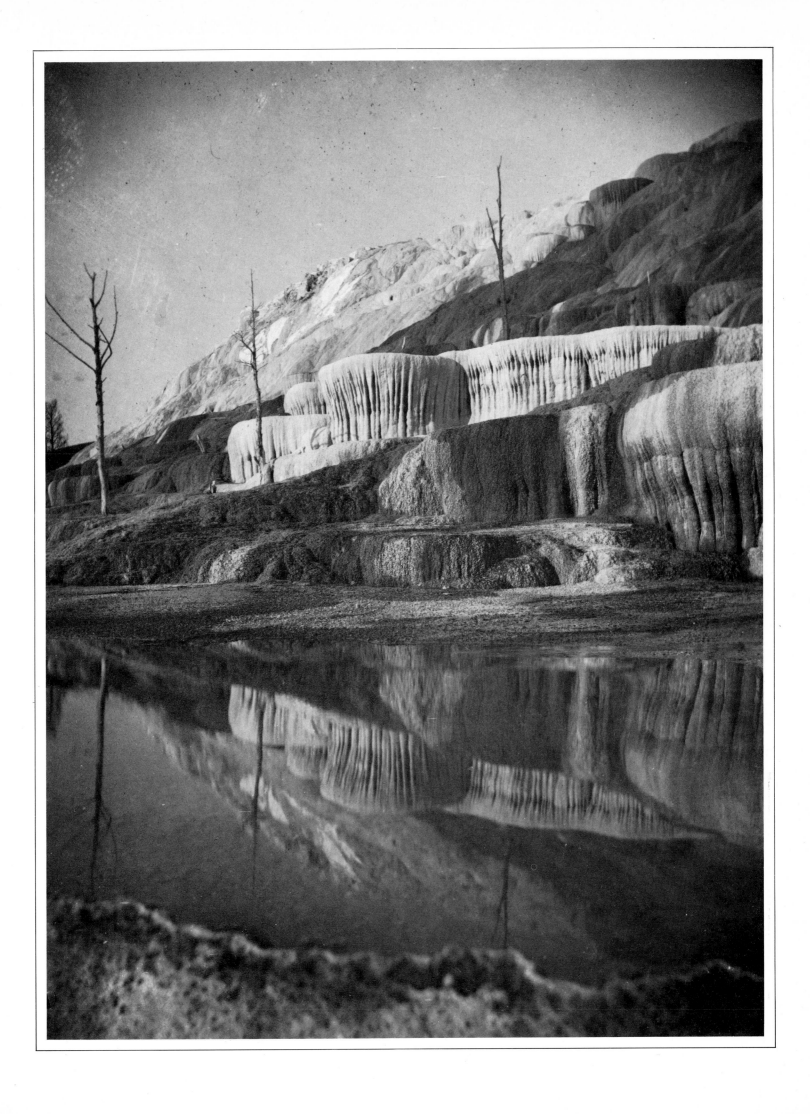

Pulpit Terraces, Mammoth Hot Springs, Yellowstone, date unknown (National Archives, Washington, DC)

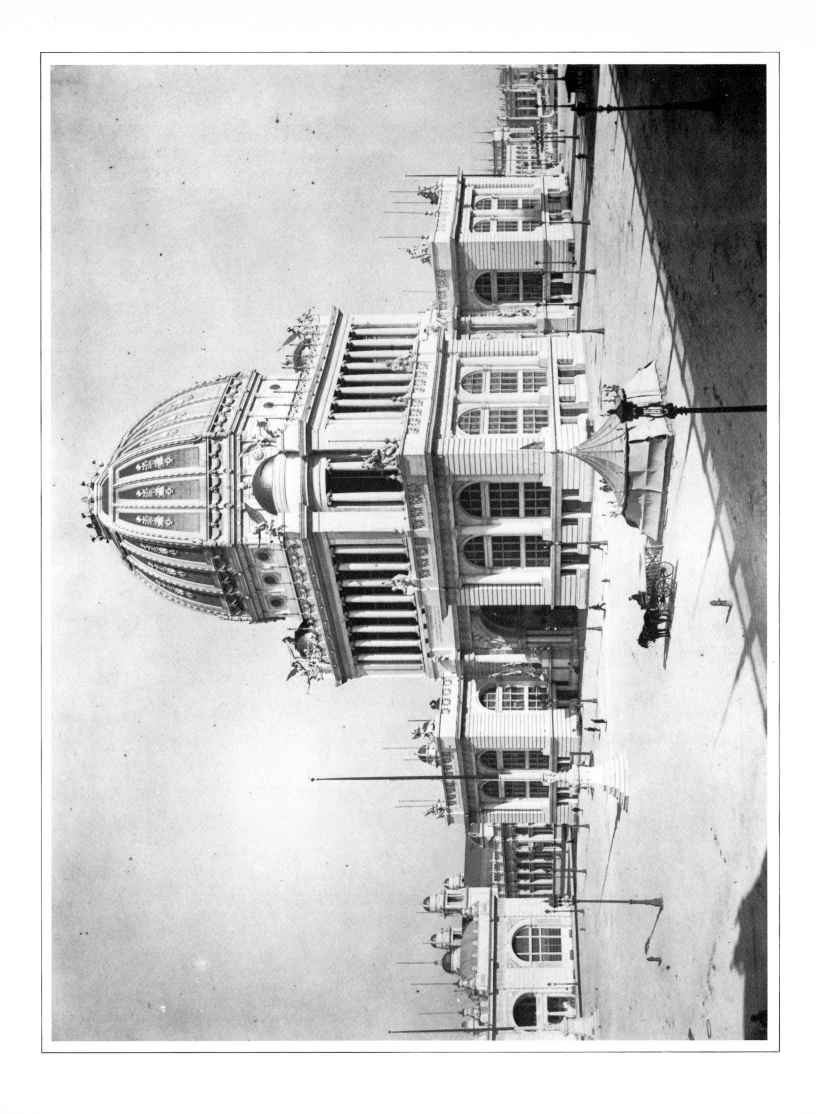

Administration Building, World's Columbian Exposition, Chicago, 1894 (Chicago Historical Society)

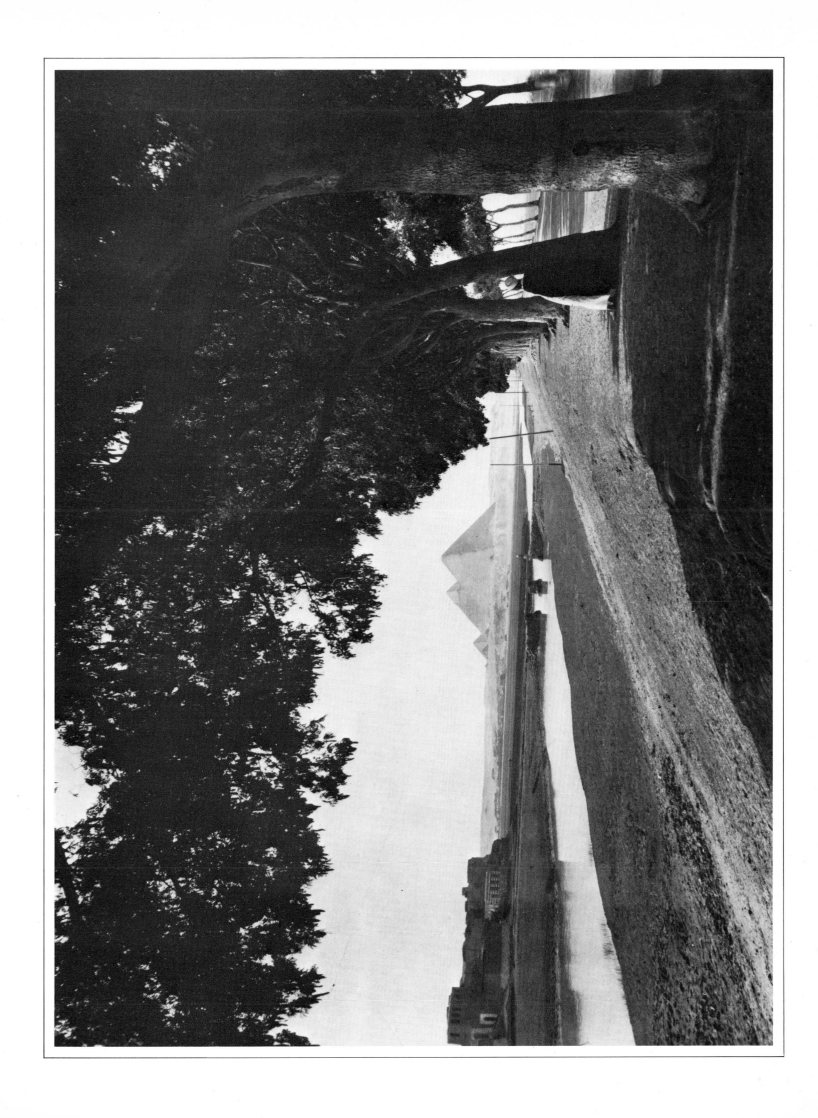

Avenue of Acacia Trees leading from Cairo to the Great Pyramids, 1894 (Library of Congress, Washington, DC)

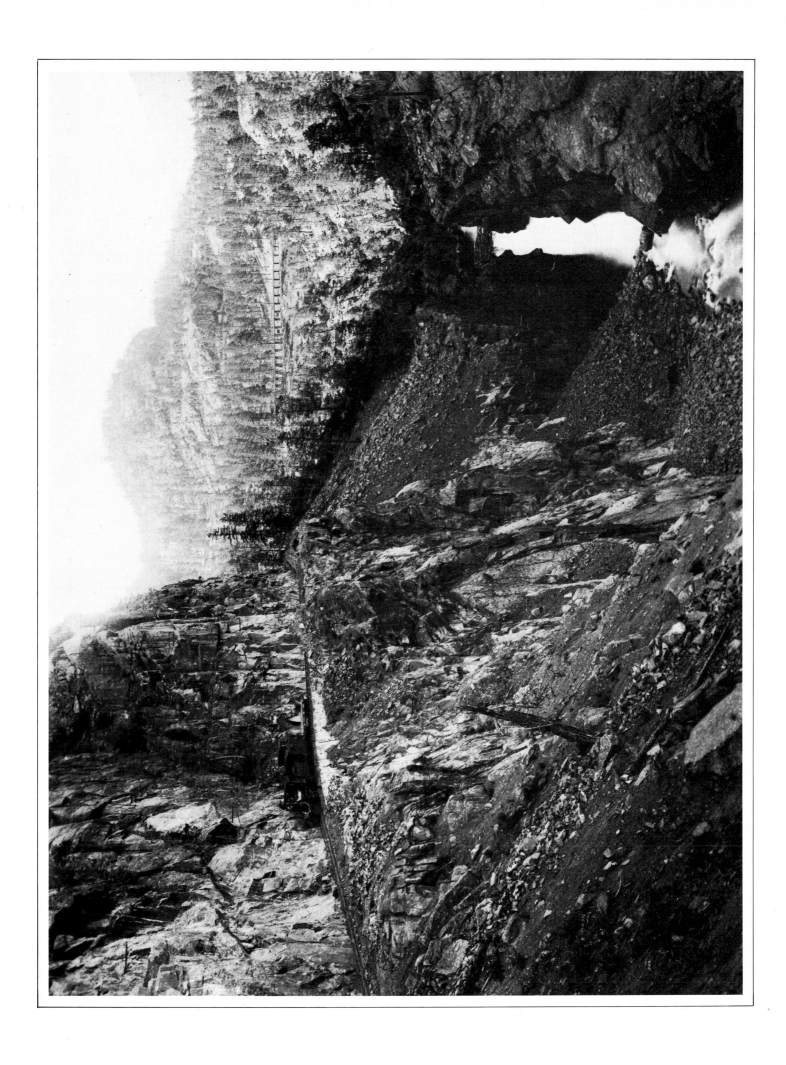

Canyon of the Rio Las Animas, c. 1880 (Colorado Historical Society)

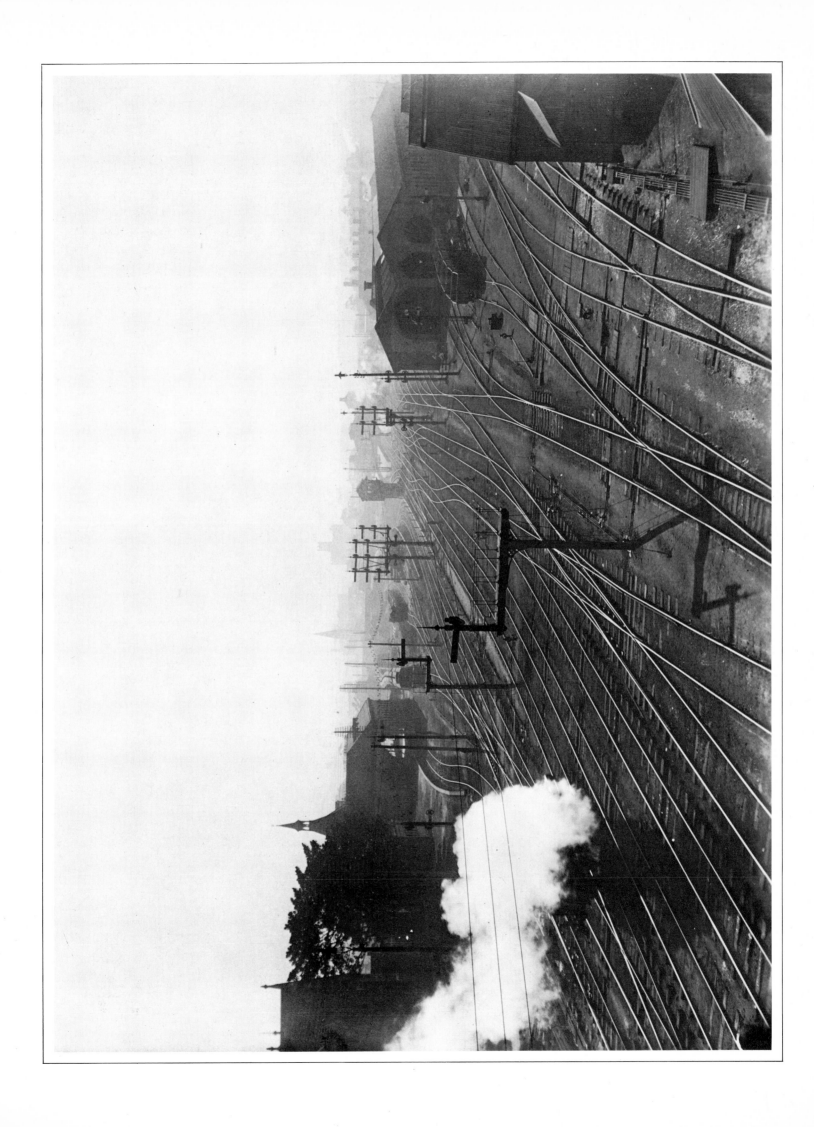

Bird's-eye view of freight yards, New Zealand, 1895 (Library of Congress, Washington, DC)

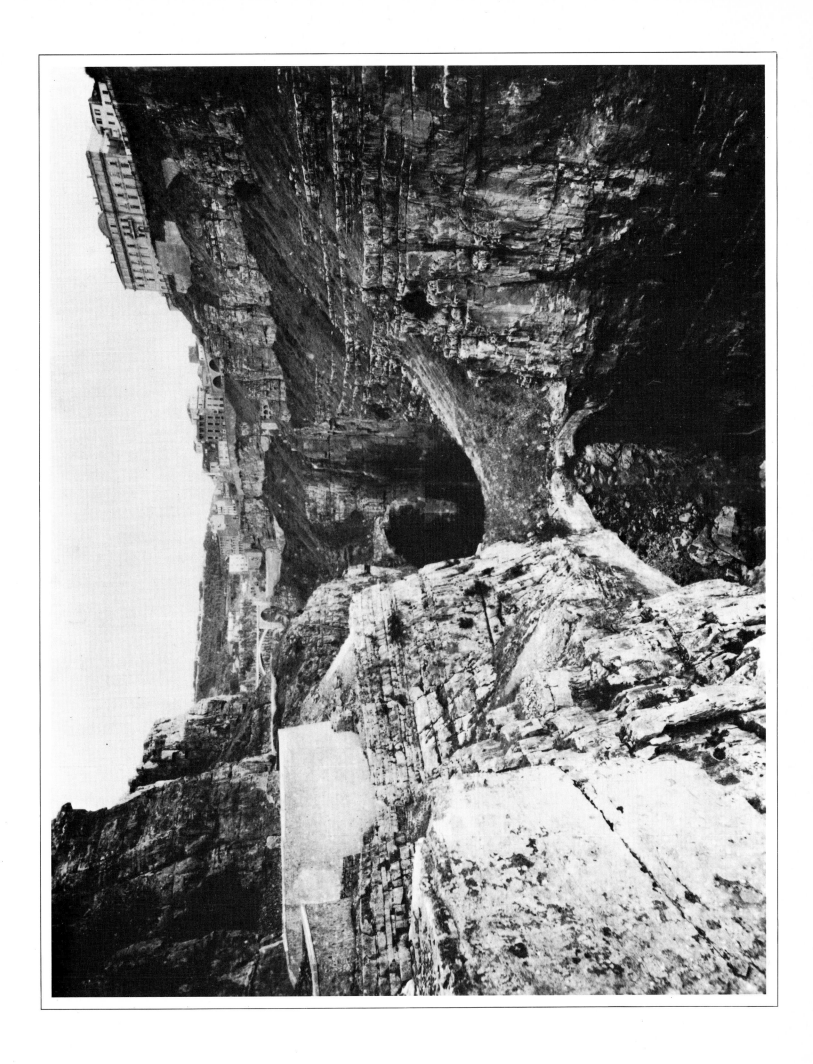

Wagon road approach to Constantine (Algiers) from the North, 1894 (Library of Congress, Washington, DC)

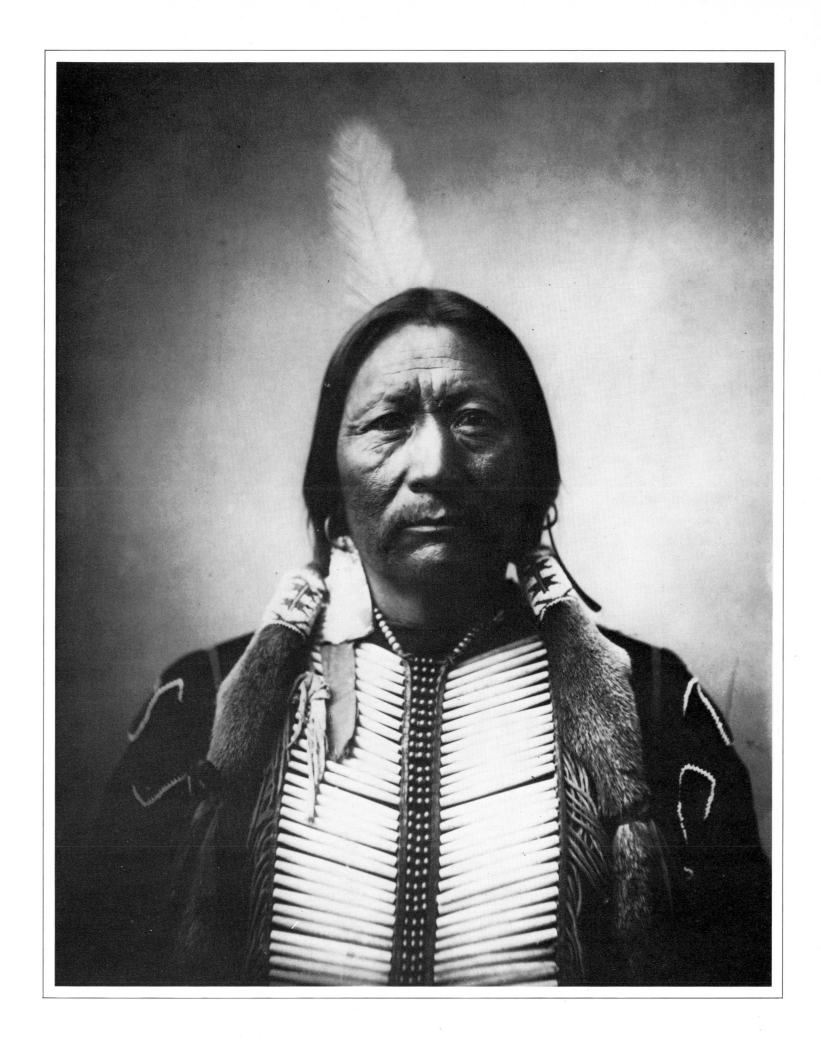

Buckskin Charlie, Ute, c. 1870 (Colorado Historical Society)

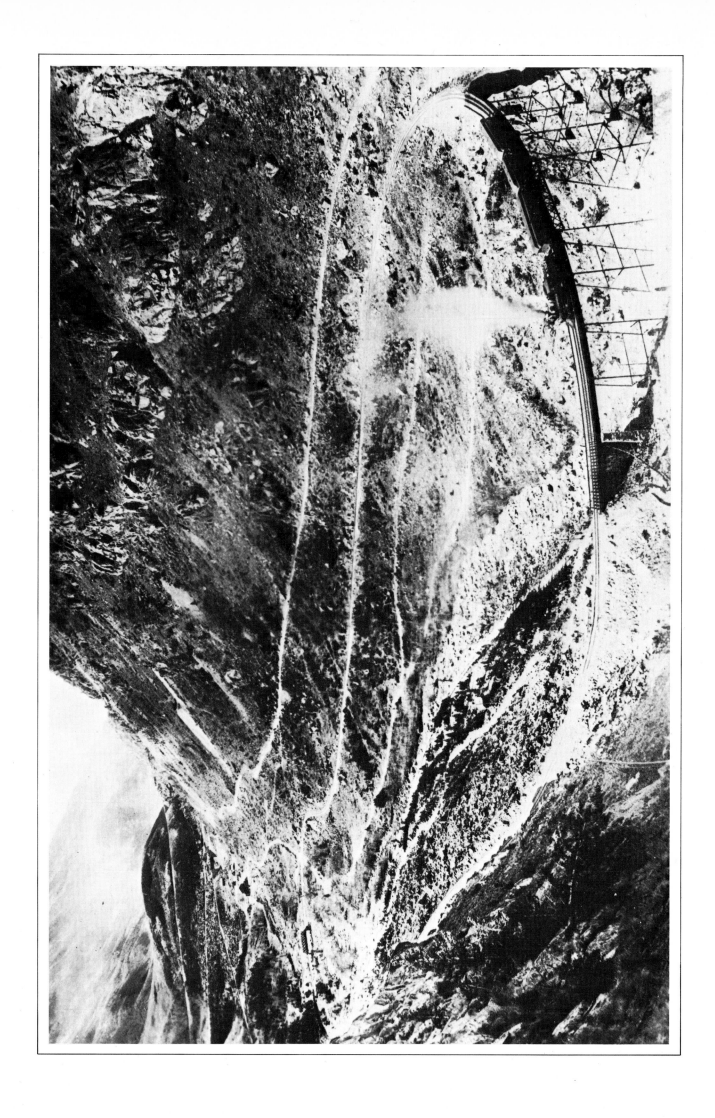

The Union Pacific Railroad, Georgetown Loop, Colorado, c. 1883 (Colorado Historical Society)

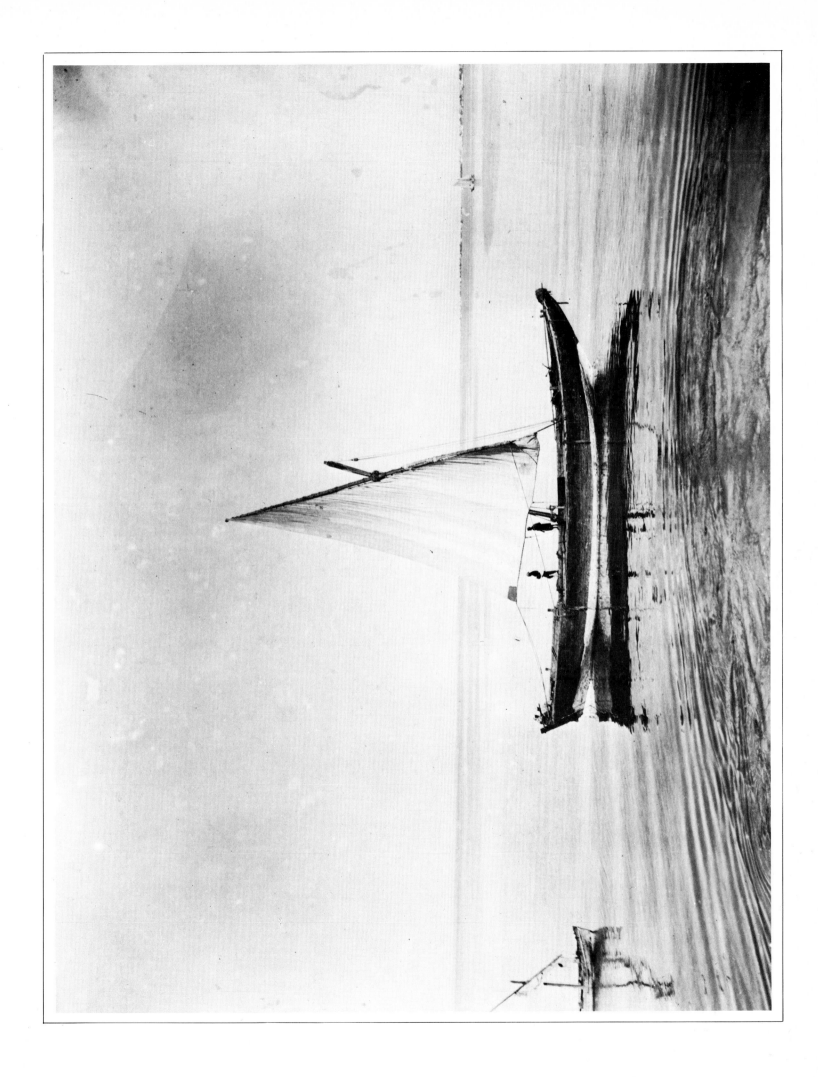

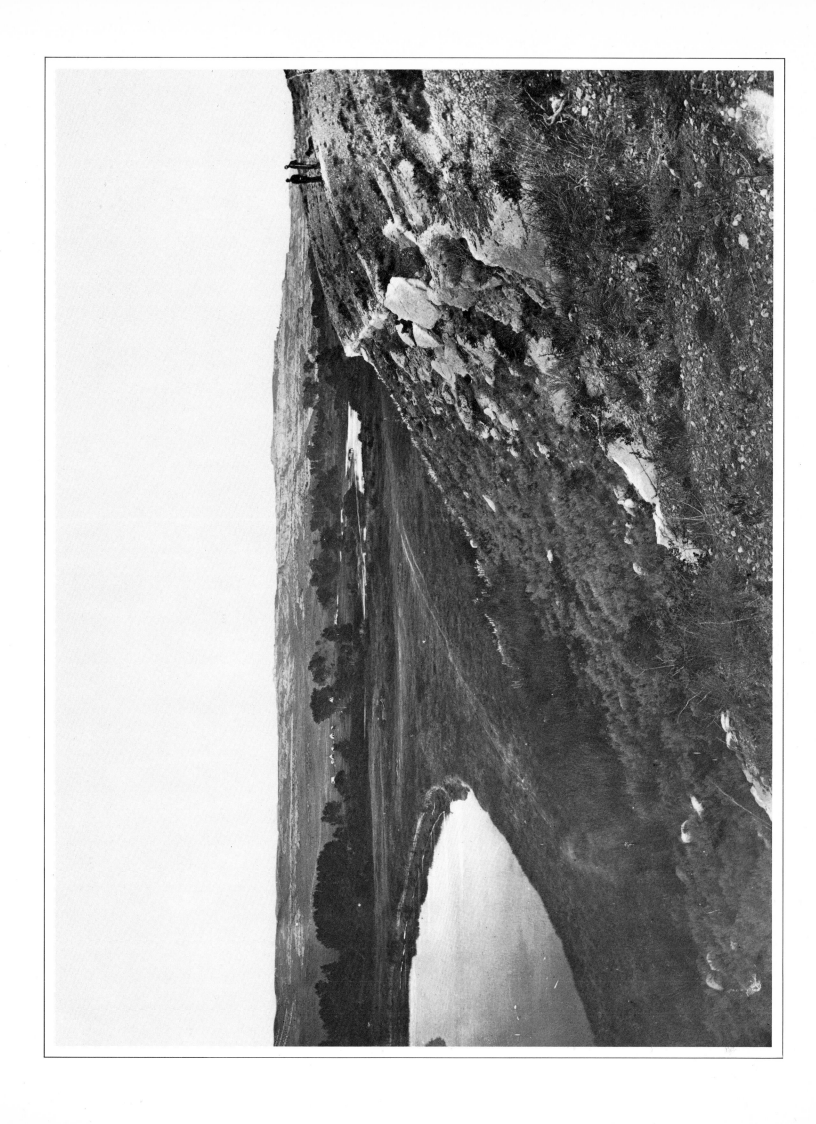

Laramie River and Valley looking northwest, Albany County, Wyoming, 1870 (National Archives, Washington, DC)

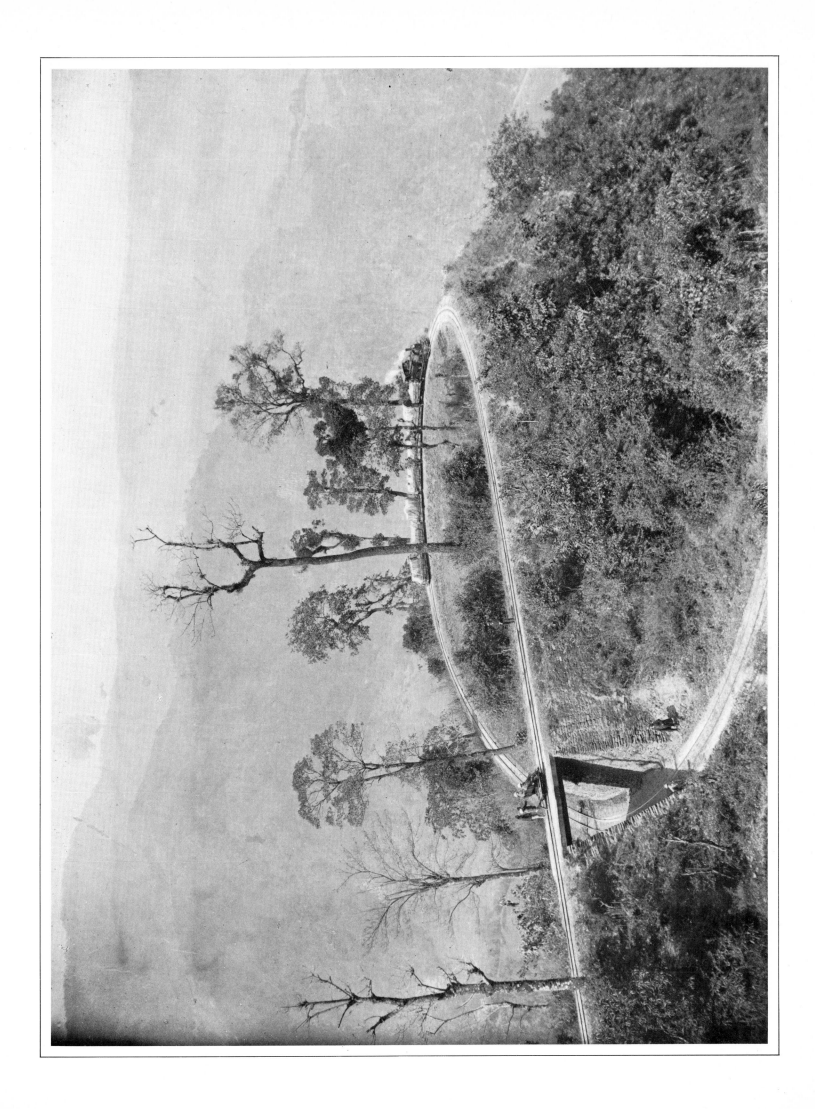

The Choonbatty Loop on the East Bengal Railway, India, c. 1895 (Library of Congress, Washington, DC)

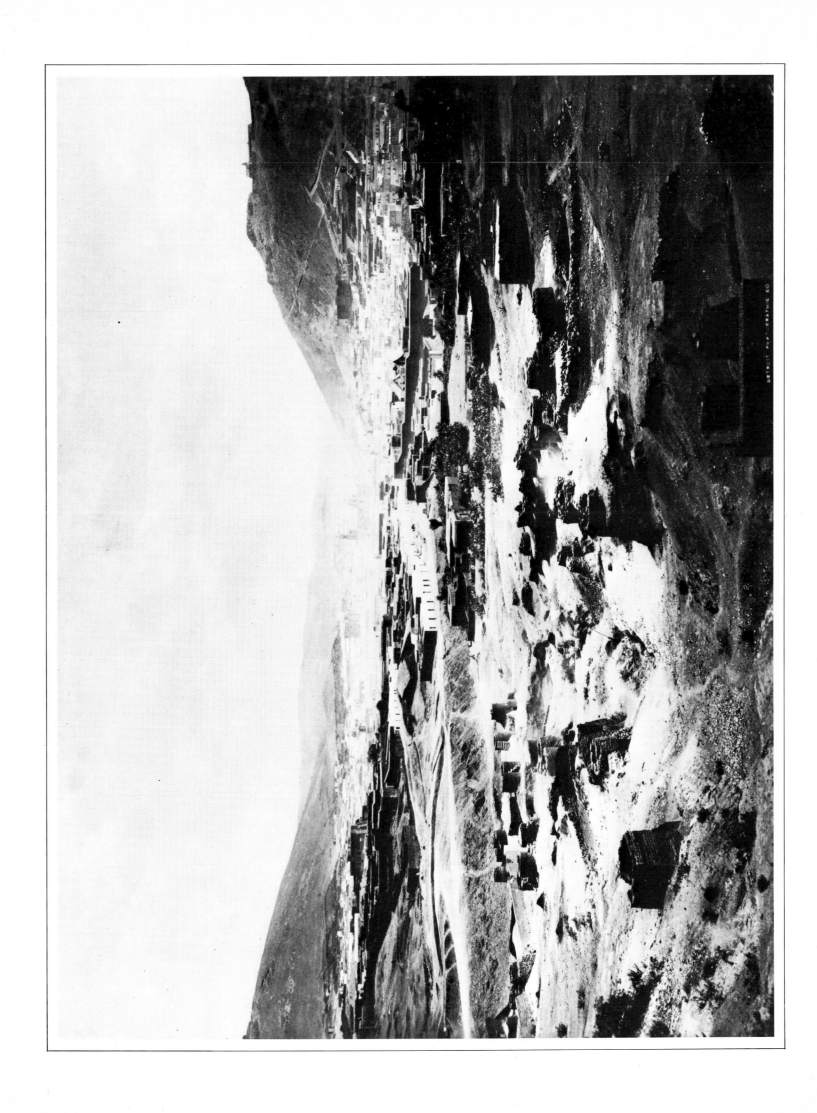

Zacatecas, Mexico, c. 1885 (Library of Congress, Washington, DC)

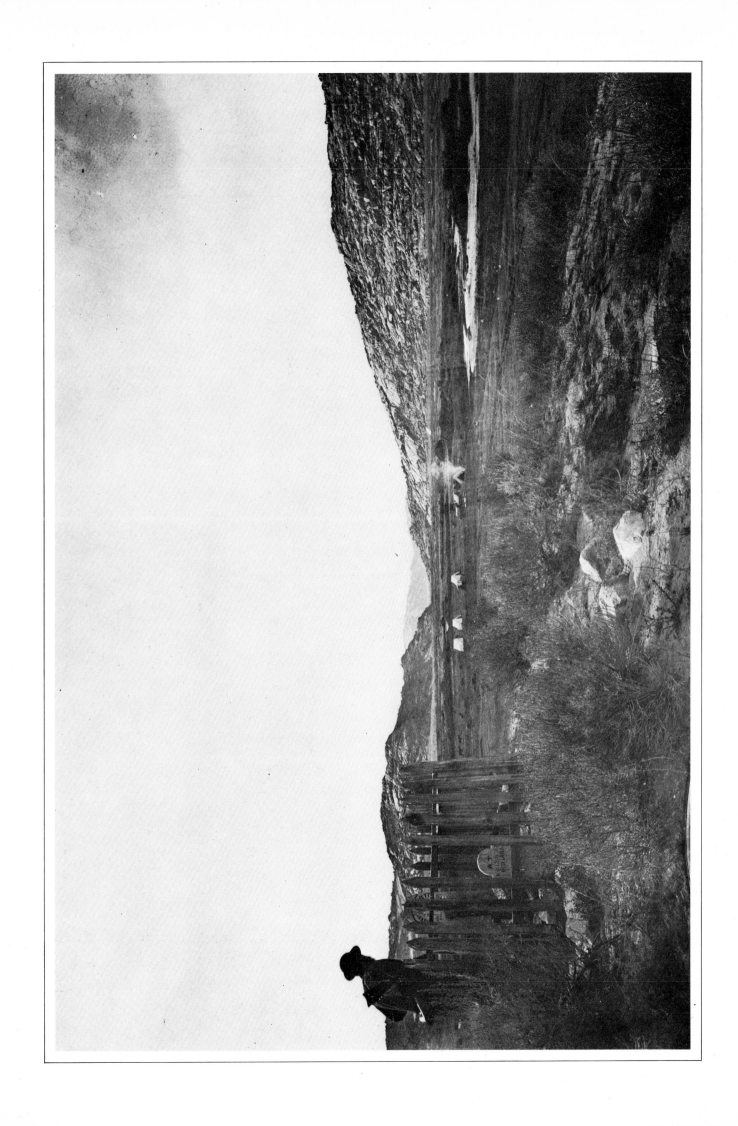

'Killed by Indians', Three Crossings, Freemont County, Wyoming, date unknown (National Archives, Washington, DC)

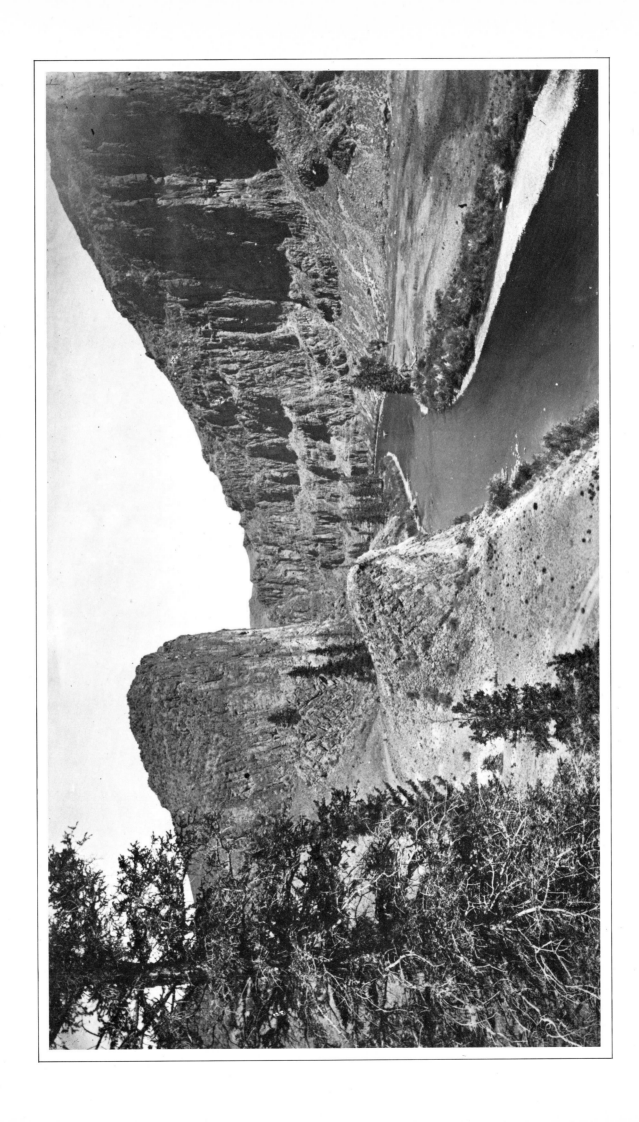

Wagon-Wheel Gap, Rio Grande, Mineral County, Colorado, 1874 (National Archives, Washington, DC)

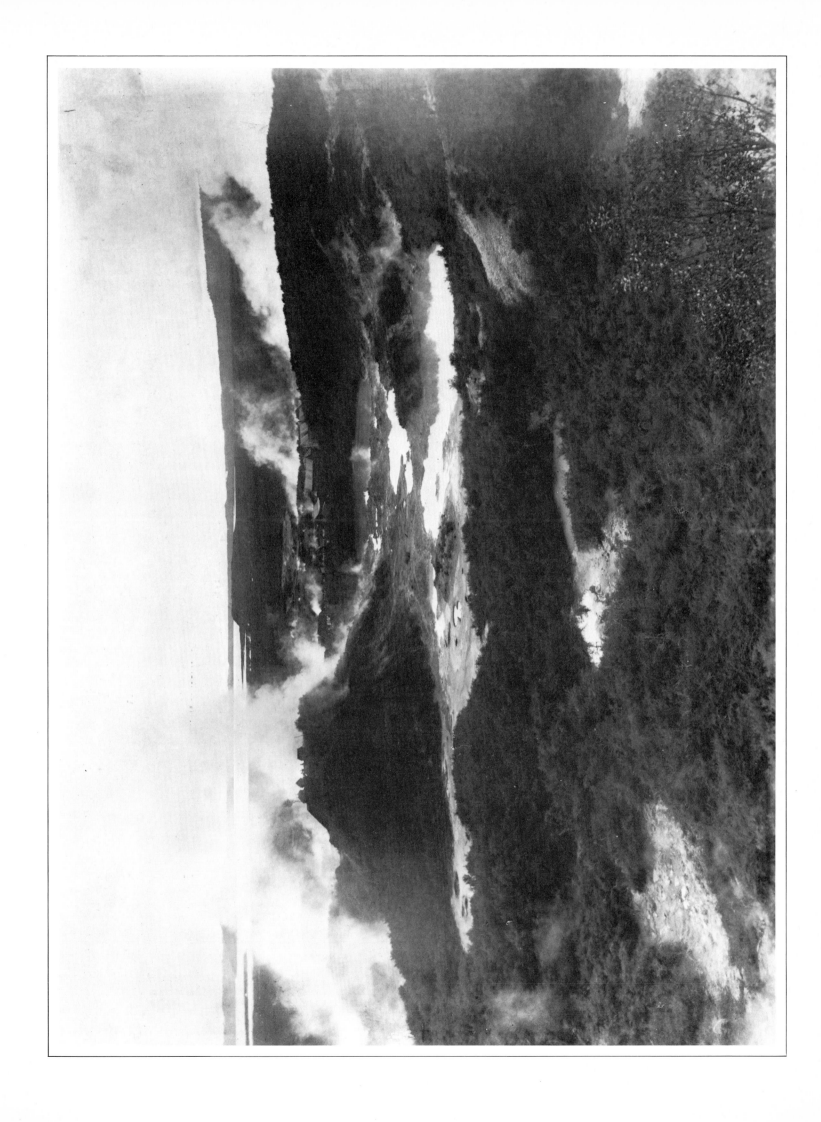

Whakarewarewa Geysers on the Waikete Geyser Crater at Hot Springs, New Zealand c. 1895 (Library of Congress, Washington, DC)

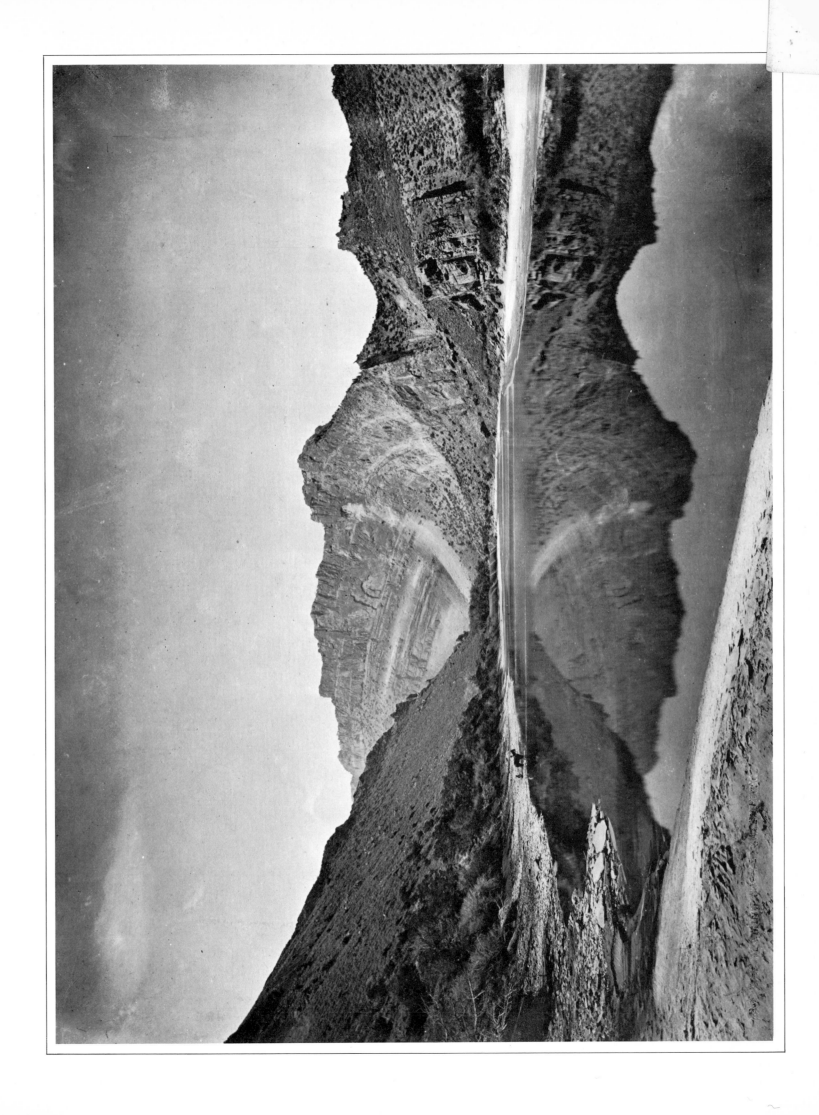

The Flamingo Gorge, a view on Green River, Daggett County, Utah, 1870 (National Archives, Washington, DC)